THE WATSON GORDON
LECTURE 2017

THE WATSON GORDON
LECTURE 2017

Classic Mondrian
in Neo-Calvinist View

JOSEPH MASHECK

NATIONAL GALLERIES OF SCOTLAND
in association with
THE UNIVERSITY OF EDINBURGH

Published by the Trustees
of the National Galleries of Scotland, Edinburgh
in association with The University of Edinburgh
© The author and the Trustees of the National Galleries of Scotland, 2018

ISBN 978 1 911054 28 3

Frontispiece: detail from Piet Mondrian
Self-portrait, 1918 (fig.7)

Designed and typeset in Adobe Arno by Dalrymple
Printed on G-Print 150gsm
by Skleniarz, Poland

FOREWORD

The publication of this series of lectures has roots deep in the cultural history of Scotland's capital. The Watson Gordon Chair of Fine Art at the University of Edinburgh was approved in October 1872, when the University Court accepted the offer of Henry Watson and his sister Frances to endow a chair in memory of their brother Sir John Watson Gordon (1788–1864). Sir John, Edinburgh's most successful portrait painter in the decades following Sir Henry Raeburn's death, had a European reputation, and had also been President of the Royal Scottish Academy. Funds became available on Henry Watson's death in 1879, and the first incumbent, Gerard Baldwin Brown, took up his post the following year. Thus, as one of his successors, Giles Robertson, explained in his inaugural lecture of 1972, the Watson Gordon Professorship can 'fairly claim to be the senior full-time chair in the field of Fine Art in Britain'.

The annual Watson Gordon Lecture was established in 2006, following the 125th anniversary of the chair. We are most grateful for the generous and enlightened support of Robert Robertson and the R. & S.B. Clark Charitable Trust (E.C. Robertson Fund) for this series, which demonstrates the fruitful collaboration between the University of Edinburgh and the National Galleries of Scotland.

The twelfth Watson Gordon Lecture was given on 9 November 2017 by Joseph Masheck, Professor Emeritus of Art History at Hofstra University, New York, a distinguished critic and former editor of *Artforum*. His work has always demonstrated an innovative and challenging commitment to modernism, and his lecture on the great Dutch artist Piet Mondrian was no exception. While the orthodox view holds that Mondrian's work was underpinned by a commitment to Theosophy, Joe Masheck opted to explore his involvement with Calvinism. Ranging across Mondrian's painted oeuvre, his engrossing lecture vividly interleaved the theological and the art historical.

RICHARD THOMSON
Watson Gordon Professor of Fine Art,
University of Edinburgh

SIR JOHN LEIGHTON
Director-General,
National Galleries of Scotland

[5]

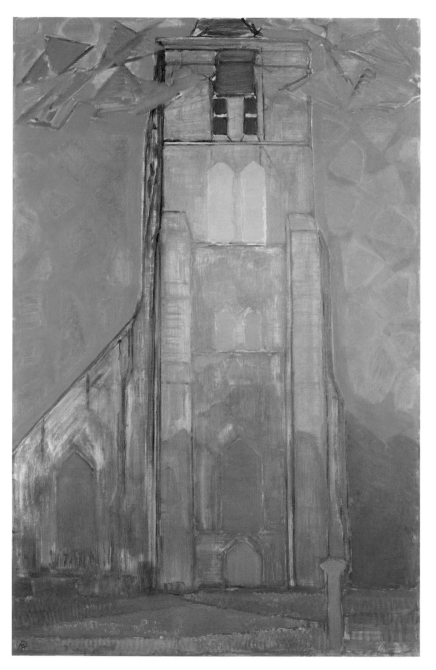

FIG.1 | PIET MONDRIAN
Church Tower at Domburg, 1911
Oil on canvas, 114 × 75 cm
Haags Gemeentemuseum,
The Hague

CLASSIC MONDRIAN
IN NEO-CALVINIST VIEW

APPROACHING THE CLASSIC PHASE

Much has been written about Piet Mondrian's (1872–1944) lingering interest in Theosophy as a presumed source of spiritual-to-artistic intuition, while too little has been written about the foundation of his faith, which was Reformed Christianity. This is important for a painter whose greatest works arose in liberating himself from nature to become one of the fathers of abstract painting. For if nature and the divine are happily one in Theosophy, Calvin more critically insists, with St Paul, that, with the Fall of Man, all Creation 'groaneth and travaileth' (Romans 8:22).[1] Not that Calvinists cannot appreciate what remained of God's glory; but one can picture young Mondrian sitting up straight to hear that nature as well as humanity come to be restored owing to Christ's Resurrection. Let us begin by indicating the artistic background to the painter's classic phase; then deal with a neglected religious facet of Mondrian's writing; next, turn to an important contemporary theologian in the Netherlands, with attention to possible analogies; and finally, follow the classic phase into the 1930s and beyond.

Calvin's iconoclasm is normally taken negatively in art history, as the reason why religious subjects were disallowed in the Protestant Netherlands. Looking back to our modern painter's juvenilia: the two-and-a-half-metre (eight-foot) canvas *Thy Word Is the Truth* (fig.2) – the title from John 17:17 – was painted in 1893–94 at the age of twenty-one by a Mondrian just starting at the Amsterdam Academy, for the Christian national school where his father was headmaster.[2] This work is an allegorical still life, enshrining the Bible, with a big doubled drape which recapitulates a seventeenth-century Dutch repoussoir device, as for instance in Emanuel de Witte's (1617–1692) *Interior of the Oude Kerk in Amsterdam*, c.1653 (Michaelis Collection, Cape Town). Young Mondrian's anchor of faith has a chain whose end points to a citation on the Bible cover: chapter 5, verse 1, of St Paul's Epistle to the Romans: 'Therefore, since we are justified by faith, we have peace with God through our Lord Jesus Christ' (Revised Standard Version).

Yet, after a hundred years of abstract painting, we can also look back at seventeenth-century Dutch interiors of whitewashed old churches with their heraldic coats of arms, often in lozenge form – as in de Witte's *Interior of the Nieuwe Kerk in Delft*, 1664 (fig.3). In Dutch the very word for painting, *schilderij*, is closely related to 'shield'; and such escutcheons – non-representational paintings displacing pre-Reformation holy pictures – are a curious Calvinist adumbration of the lozenge paintings of the Dutchman Mondrian during his classic phase: here *Lozenge Composition with Red, Black, Blue, and Yellow*, 1925 (fig.4).[3]

Works of Mondrian's early maturity, such as the planar façade of the *Church Tower at Domburg*, 1911 (fig.1), are essentially post-impressionist until he experiments with Cubism in Paris in 1912–14. Then, the drawing *Church Façade 1*, 1914 (fig.5) is cubistic, not only for its oval field and the disjunct intersections and curves within it, but also for the arbitrary semantic displacement of the steeple to the bottom of the field. This was Mondrian's local, partly Gothic, town church – Reformed, of course. Already he was more at home with the regulated relief of such a façade than with a figure. An early approach to the new mode, a 1912 *Portrait of a*

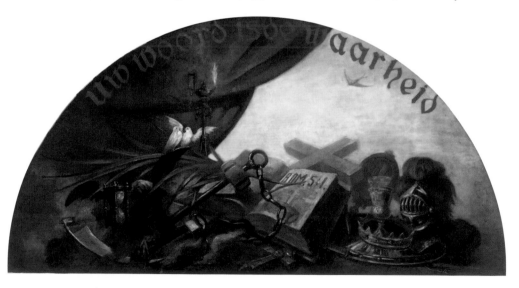

FIG.2 | PIET MONDRIAN [THEN MONDRIAAN]
Thy Word Is the Truth, 1893–94
Oil on canvas, 150 × 250 cm
Villa Mondriaan, Winterswijk (on long-term loan from the
Collection of School Community Accent, Aalten)

Lady (fig.6), confronts this problem by subsuming the figure as far as possible to its similarly opaque and angular surroundings, while a later *Self-portrait*, 1918 (fig.7), from soon before the classic phase, abandons Cubism, juxtaposing an abstract composition with a head that does not quite know what to do with itself in so far as it is naturalistically unreformed.[4]

It was from his favoured category of landscape, including architectural structures, that Mondrian would make his end-run to abstraction. From the seaside at Domburg, too, come images of 'Pier and Ocean'. A dialectic is at work in them, including the natural and the man-made, atmosphere and scope. The drawing *Pier and Ocean 5 (Sea and Starry Sky)*, 1915 (fig.8) and the painting *Composition 10 in Black and White; Pier and Ocean*, 1915 (fig.9), deriving from a view of sky and sea seen from a pier projecting towards the horizon, show something great emergent. To one of these works I once responded spontaneously in a television interview, as it occurred to me that the setting and the observer's viewpoint evoke a famous remark of Immanuel Kant, near the end of *The Critique of Practical Reason* (1788): 'Two things fill the mind with ever new and increasing admiration and awe, the oftener and the more steadily we reflect on them: the starry heavens above and the moral law within.'[5]

Yve-Alain Bois is right that Mondrian's development is inherently dialectical, though he is not alone in referring anything philosophical, such as Kant or Hegel, to the contemporary Dutch reactionary populariser Gerardus Bolland.[6] There is, however, a problem today with Hegel himself, concerning the crucial notion of *Aufhebung*: that dialectical principle whereby something is negated yet 'sublated' in overcoming negation. For many Hegelians now are insufficiently dialectical about religion: applauding only 'Left Hegelianism', they ignore the 'Right Hegelianism' which claims Hegel as a Lutheran believer. One would never guess that Martin Luther actually used the supposedly ultra-Left Hegelian verb *aufheben* (to sublate) in his translation of the Bible.[7]

Moving along: Mondrian's *Composition in Line*, 1916–17 (fig.10) – with Cubism plus the 'Pier and Ocean' series behind it – takes us only a step or two away from the first paintings with irregular ranges of colour patches, while *Composition in Colour B*, 1917 (fig.11) has line and colour in overlap or syncopation.

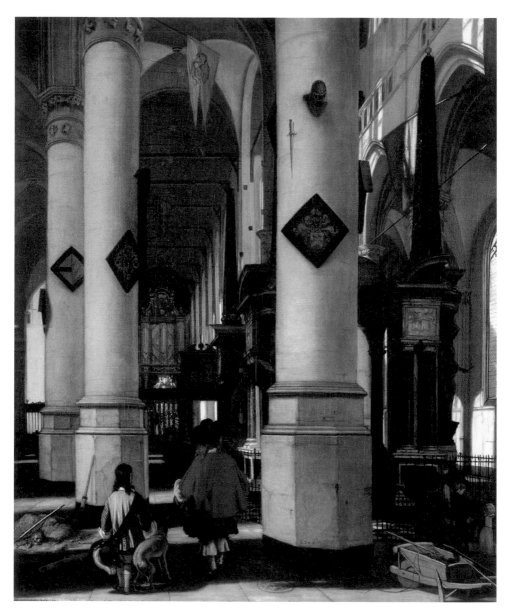

FIG.3 | EMANUEL DE WITTE
Interior of the Nieuwe Kerk in Delft, 1664
Oil on canvas, 78.9 × 67 cm
Residenzgalerie, Salzburg

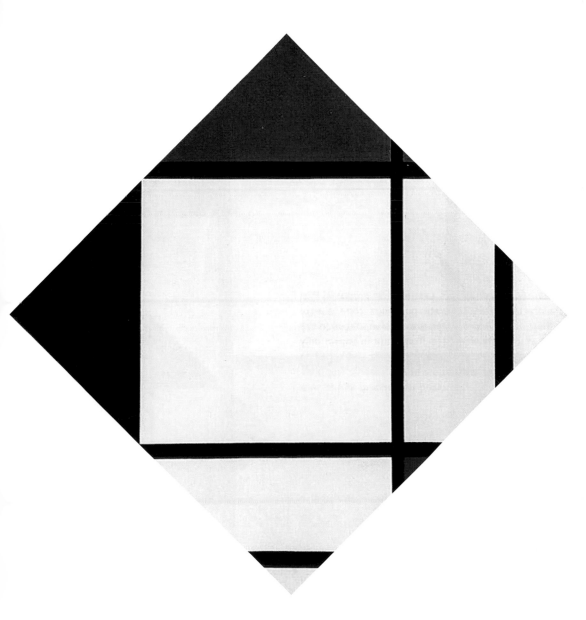

FIG.4 | PIET MONDRIAN
Lozenge Composition with Red, Black, Blue, and Yellow, 1925
Oil on canvas, 77 × 77 cm (108 cm diagonal)
Private collection

It is with several 'Compositions with Colour Planes', including *Composition with Colour Planes 3*, 1917 (fig.12), that Mondrian identifies himself – in ghostly white-on-white, and not with any discernible one of them – in the *Self-portrait* (fig.7) of a year later. Highly intuitive in regard to the placement of elements, these relate more closely to the classic paintings than their pale colours might indicate. In fact, the classic paintings favour not so much primary colours as what could be called *categorical* colours, whereby a red is red enough to establish itself in respect to anything categorically yellow or categorically blue; but in the various 'Compositions with Colour Planes' the pastels are too tonally similar to matter that way. An emphasis on astutely intuitive composition is highlighted in contemporary art by comparison with arrays of squarish snippets in the Dada collages of Jean Arp (1886–1966), such as *Untitled (Squares Arranged According to the Laws of Chance)*, 1917 (fig.13). I admire such Arps, but except for pulling the pieces out of a bag I do not think they have much to do with chance because the arrangements look a bit hedged. (Dadaists do not believe in predestination, do they? Perhaps in Zurich they did!) These 'Compositions with Colour Planes' already have the sort of electromagnetic field of the classic paintings, wherein each form responds to its neighbours, determinately positioned in regard to multiple adjacent effects. Soon Mondrian will include line – an asymmetrical lattice of grey and then black lines together with colour patches – in formulating the quintessential style.

The 'classic' phase of the 1920s and 1930s developed when Mondrian returned to Paris.[8] The composition now consists of black rectilinear lines against a field of white, or whites, with interstices between them, some as areas occupied by categorical colours. A wonderful example is *Tableau 2*, 1922 (fig.15), which shows the painter's rectilinear compositions attaining an extraordinarily active, vital equilibrium. Here we see the relative weights of the colour patches in remarkable asymmetric balance as the three colours manage to touch all four sides despite one entire corner being given over to a comparably solid rectangle of black. The black patch, together with two discernibly different whites, comprises something like a rival triad of non-colours. Slim partitioning bands either do, or decidedly do not, touch – or exceed – the edge, while the halving of the open zone at the top, split between white and yellow, is like the halving at the left between white and blue,

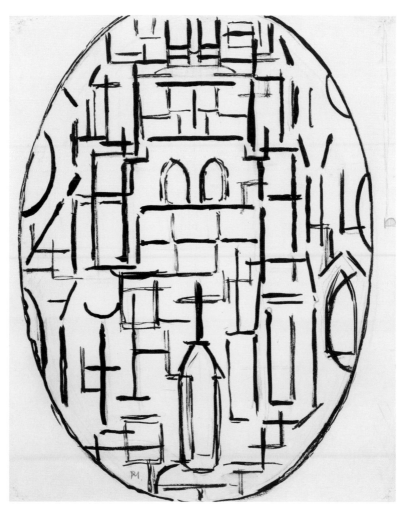

FIG.5 | PIET MONDRIAN
Church Façade 1, 1914
Charcoal and ink on paper, 63 × 50 cm
Haags Gemeentemuseum, The Hague

which also makes for a whole corner wide open to white as counterpart to the similarly two-sided corner devoted to black. However difficult to describe, the painting testifies to an astute play of visual intelligence, striking all at once like a strong, pure chord. The practically magnetic interdependence of parts is a pure form of that 'relational composition' which long served painting as an armature for standard pictorial representation, now purged of descriptive reference.

JUSTIFICATION AND THE WORLD TO COME

Artists often write about their worldviews in the subjective frameworks of letters, diaries and notebooks, which are sometimes problematic as to intended destinations. Fortunately, Mondrian addressed posterity with a great deal of formal, published writing, some of it touching on religion, and some of it seeming analogically theological. As a lifelong admirer of this artist, I have long retained a notion that his abstract 'Neo-Plastic' compositions of the 1920s into the 1930s practically thematise theological justification. Usually Mondrian uses the term 'equilibration' in the writings, i.e., to bring into equilibrium. Because this most likely entails a *justification* out of previous disequilibrium, once the white canvas has been painted upon, a theological terminology of justification in respect to the Fall of Man seems appropriate. And because justified works may go to advance the ultimate utopia of the New Jerusalem, or the kingdom of God and his justice, Mondrian's ongoing mentions of religion are hardly trivial in regard to his artistic practice. Surveying his most relevant published statements will set the scene for contemporary Dutch theological parallels.

Justification, by which sin since Adam and Eve is atoned for and by grace forgiven, is a matter of divine economy. One speaks of sins' remission, meaning that something is remitted like payment for a debt. In the *Institutes of the Christian Religion*, Calvin's sense of justification consists of a remission of the debit of sin thanks to the gratuitous credit of the righteousness of Christ (III.xi.xx).[9] Analogically, the play of variables in an abstraction by Mondrian, including proportions and colours of the rectangular areas, and their relative distances and positions, will seem, when attuned, 'justified' in a sense analogous to the theological meaning.

It is noteworthy that the theology of justification also has a 'common sense'

[14]

aspect, with respect to craft, as not irrelevant to painting. Craftspeople know justification as a setting right, getting things 'squared away': the carpenter justifies edges by eliminating a discrepancy, as the printer justifies type in respect to column and page – both, no doubt, with a good feeling of making things right. Mondrian must entertain disunity before making good on it; but once equilibrium has been achieved, some idealistic things prove to be worth the effort: as if the painting got to say, '*Now* who's being "realistic"!' As a matter of fact, Mondrian *did* like to say that – as against any spurious realism settling spiritually for so much less. Cardinal Newman was still an Anglican when he wrote:

> In the abstract [justification] is a counting righteous, in the concrete a making righteous … Serious men, dealing with realities, not with abstract conceptions, … not refuting an opponent, but teaching the poor, have … taken it to mean what they saw, felt, handled … When they speak of justification, it is of a wonderful grace of God, not in the heavens, but nigh to them.[10]

From the time of the formation of the De Stijl movement (in 1917) onwards, Mondrian identified his artistic ideal as the achieved asymmetric balance of an 'equilibrated plastic' relationship. Eventually, in 'The new art – the new life: The culture of pure relationships' (1931), he would allude to the theological underpinning, the Fall of Man: since before the Fall, Adam enjoyed 'perfect equilibrium', and afterwards, justification became a struggle requiring 'outside opposition' (likely grace?).[11] One can see this as explaining the sense of active equilibrium entailed in a classic Mondrian composition: how such a work appears *rendered to be* asymmetrically perfect.

Mondrian's wonderful asymmetric equilibrations were a revelation to me in my youth. I have never forgotten looking at examples in New York's Museum of Modern Art, at age fourteen or fifteen, while overhearing a docent, nearby, highlighting the relational character of a certain painting's colour patches. He must have pointed up red and/or yellow, because sixty years later I remember him saying, 'How much blue does the eye need?' I knew this was how I already saw Mondrian's paintings, and it had to do with actively effecting an asymmetric balance, which before long I quite understood as a justification, with the Reformation in mind. Let us then refer the constant refrain of plastic equivalence, found everywhere in

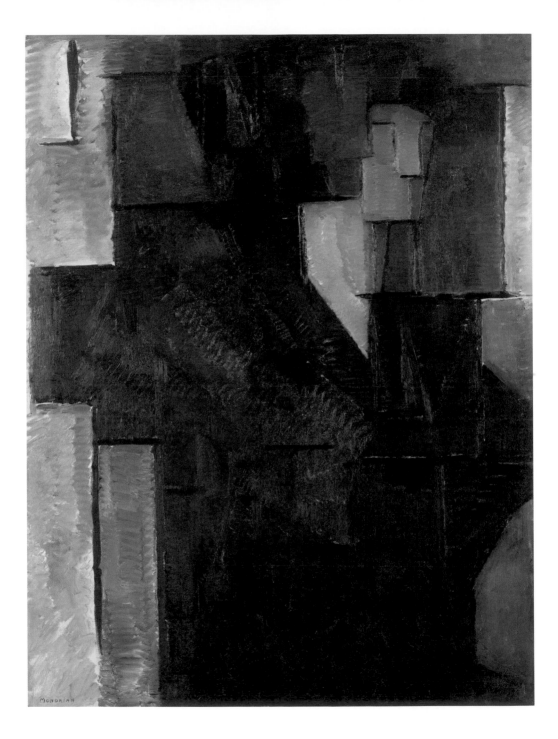

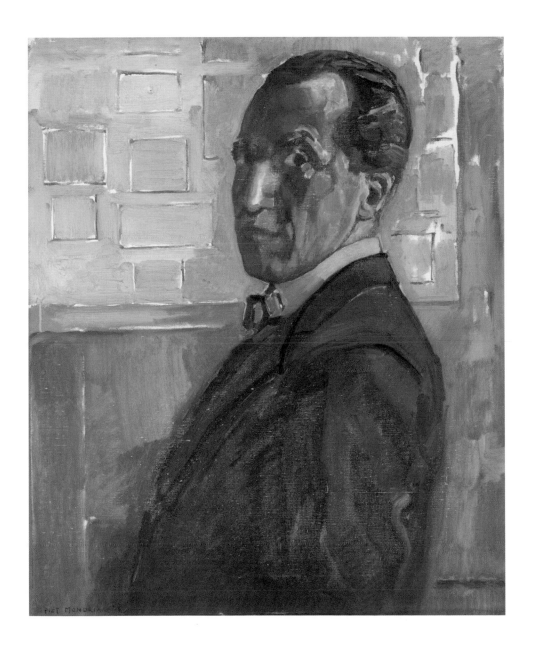

FIG.6 | PIET MONDRIAN
Portrait of a Lady, 1912
Oil on canvas, 115 × 88 cm
Haags Gemeentemuseum, The Hague

FIG.7 | PIET MONDRIAN
Self-portrait, 1918
Oil on canvas, 88 × 71 cm
Haags Gemeentemuseum, The Hague

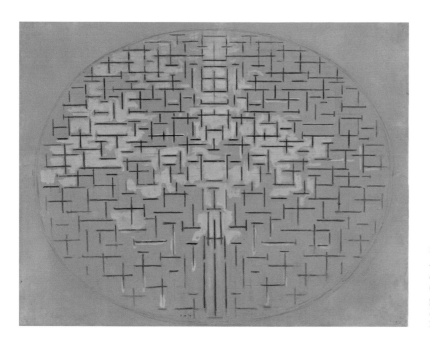

FIG.8 | PIET MONDRIAN
*Pier and Ocean 5 (Sea
and Starry Sky)*, 1915
Charcoal and watercolour on
paper, 87.9 × 111.7 cm
Museum of Modern Art,
New York

FIG.9 | PIET MONDRIAN
*Composition 10 in Black and
White; Pier and Ocean*, 1915
Oil on canvas, 85.8 × 108.4 cm
Kröller-Müller Museum, Otterlo

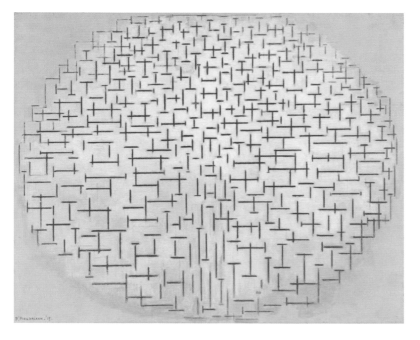

this painter's writings, to the notion of justification for this Protestant among the 'fathers' of abstract painting, especially in respect to the settled asymmetries of his characteristic works of the 1920s and 1930s. If this seems a single-minded view of Mondrian's work, it is nevertheless a comprehensive one.

In Mondrian's first published essay, written at home during the First World War and titled 'The New Plastic in painting' (1917), we already seem to have a believer on our hands: '*In abstract-real plastic man has an opposition to the natural through which he can know nature and thus gains knowledge of the spirit. In this way art becomes truly religious.*'[12] Again: 'truly modern man sees things *as a whole* and accepts life *in its wholeness*: nature and spirit, world and faith, art and religion – man and God, as *unity*.'[13] As the painter says, the new painting developed as modernity brought recognition that '*every expression manifesting life – including art – is good and justified; that all expressions of real life are completely justified, even in their imperfection.*'[14] Surely such a statement already compares with the most famous dictum of Dutch Neo-Calvinism: the claim of Abraham Kuyper – soon to be discussed – that over 'every square inch' of Creation the risen Christ says, 'This is mine!'? Mondrian says that both pietistic religion and secular socialism are inadequate to the spiritual requirements of humanity: the one being too inward, and the other too outward; hence 'true socialism signifies *equilibrium* between inward and outward culture'.[15]

A philosopher, Hendrik Matthes, has raised the question of justice, aside from religion, in elucidating what Mondrian meant by an 'exact plastic of mere relationship', speaking of his 'Neo-Plastic prophetic vocation' of heralding 'the realization of universal harmony', and quoting him, as of 1918–19 in the journal *De Stijl*, house organ of the movement, that 'equilibrated relationship in society signifies what is just'.[16] But having already heard Mondrian speak of religion, one wants to see how this related to contemporary Reformed theology. In the 'Dialogue on the New Plastic' (1919), a year after his *Self-portrait*, Mondrian writes:

> If ... we see that equilibrated relationships in society signify what is *just*, then one realizes that in art too the demands of life press forward when the spirit of the times is ripe ... All expressions of life – religion, social life, art etc. – always have a common basis. We should go into that further: there is so much to say.[17]

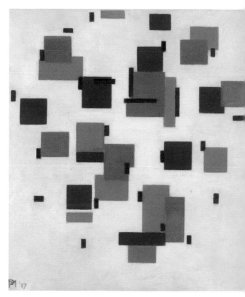

Begun in the Netherlands and finished in Paris, Mondrian's 'Natural reality and abstract reality; a trialogue (while strolling from the country to the city)' (1919–20) is a conversation among an 'abstract-real' painter, a naturalistic painter and a layman. Shifting into his classic style, our 'abstract-real' painter here spells out the play of reciprocalities in the new painting as the principle of an harmonious society: *'Pure plastic vision must construct a new society, just as it has constructed a new plastic in art – a society where equivalent duality prevails between the material and the spiritual, a society of equilibrated relationship'.*[18] The future is seen eschatologically: before the world to come, the abstract-real painter expects first to see 'joy and suffering … *opposed in equivalence'*; only then, after *'repose'*, will come a 'deepened beauty enabl[ing] us to experience the feeling of freedom, which is joy'.[19] The new society will integrate material and spiritual human needs; but 'We must begin by sacrificing ourselves for an ideal, because at present the new society is no more than that. *In everything we do* we must begin by *creating an image of what society must one day make a reality.'*[20] Showing forth nothing but plastic equivalences or 'justifications', Mondrian's abstract painting makes the utopian condition imaginable.

Mondrian composed the short book *Neo-Plasticism: The General Principle of Plastic Equivalence* (1920) as a summary theoretical statement, in French, applied

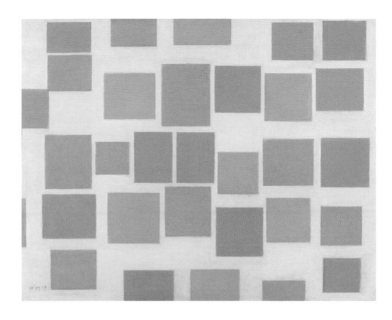

to all the arts at the take-off point of his definitive Neo-Plastic phase. Basically, the plastic arts mean painting, sculpture and architecture as arts in which material accepts the forms imposed by the artist. The equivalent Dutch term 'Nieuwe Beelding' – which, having sought advice from a native speaker, I venture to translate as 'New Rendition' – had some Dutch cultural currency around the turn of the century, including in Theosophical circles.[21] As 'Neo-Plasticism' was now being framed almost as a trademark, Mondrian set out this robust position paper, referring to his own previous essays concerning this style of which he would be captain. He wanted to eliminate the notion that his art has anything to do with subjective sensibility, as associated with a Romantically distasteful sense of 'the *tragic*': so his own dialectic disdains subjective effects in favour of a bifurcation between an individual '*universal in us*' and a social '*universal outside us*'.[22]

Interestingly, Mondrian could even joke about his Calvinism. Many will think about the famous late painting *Broadway Boogie-Woogie* on reading 'The manifestation of Neo-Plasticism in music and the Italian Futurists' *bruiteurs*' (1921), where, hoping to extend his Neo-Plasticism to music, Mondrian manages to effect two gentle insider blasphemies against Calvinist strictness. The backstory here is Calvin's wishing to confine church music to psalm-singing. So Mondrian can say,

'most people do not understand that the "spiritual" is better expressed by some ordinary dance music than in all the psalms put together'.[23] Again: once our barbarous nature is overcome, like the Futurists we will prefer mechanical sounds, and '*with regard to its timbre*, the rhythm of a pile driver will affect [one] more deeply than any chanting of psalms'.[24]

The 1922 essay 'The realization of Neo-Plasticism in the distant future and in architecture today' voices one of the painter's most Hegelian statements: 'Art advances where religion once led', continuing with a Calvinist claim about the fallenness of the world: 'Religion's basic content was to *transform the natural*; in practice, however, religion always sought to harmonize man *with nature*, that is, with *untransformed* nature'.[25]

'Home – street – city' (1926) suggests that the new art, in our intermediate state, can be a compensation during the construction of the world to come.[26] Soon our painter became more political about the unredeemed world, taking justification in the sense of social justice, in 'Pure abstract art' (1929):

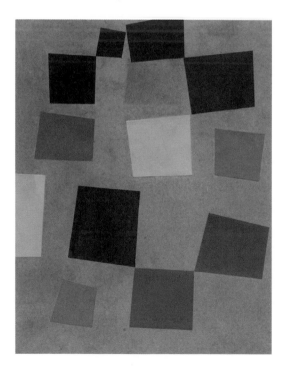

FIG.13 | JEAN (HANS) ARP
Untitled (Squares Arranged According to the Laws of Chance),
1917
Cut and pasted coloured paper on coloured paper, with ink and bronze paint, 33.2 × 25.9 cm
Museum of Modern Art, New York

Pure abstract art becomes completely emancipated, free of naturalistic appearances. It is no longer natural harmony but creates equivalent relationships. The realization of equivalent relationships is of the highest importance for life. Only in this way can social and economic freedom, peace, and happiness be achieved … Inequivalent relationships, on the other hand, the domination of one over another or over others, have always led to injustices.[27]

In the great later essay 'Plastic art and pure plastic art' (1936), dissatisfied with the public reception of his project, the painter wonders if it is 'attempt[ing] the impossible'. After all, attempting to make art 'comprehensible to everybody' *is* attempting the impossible. You cannot reach everybody, because 'the content will always be individual'; besides, 'Religion, too, has been debased by that search'.[28]

But our artist's apparent belief in principles congruent in all but name with justification and the kingdom of God is striking in respect to contemporary Dutch Neo-Calvinism. We can now consider important religious goings-on in the cultural setting of Mondrian's formation, especially up-to-date Neo-Calvinist writing, because that was also what was being preached and talked about – including extramural applications of Christian commitment.

Between the two textual parts of our discussion, let us juxtapose another classic painting from the year before *Tableau 2*, namely, *Composition with Red, Blue, Black, Yellow, and Grey*, 1921 (fig.14), side by side to the left, as predecessor, of *Tableau 2* (fig.15). Here we see left-to-right, top-and-bottom compositional inversions. The red horizontal oblong in the first painting is adjacent to or atop its accompanying perpendicular lines in the upper left of the first, but underneath the perpendicular lines accompanying it in the lower right of the second. Each work offers certain alternative parallels to the other, subject not so much to negation as to exchange on par. We may think of their temporal succession as similar to the way we are about to take Herman Bavinck as prior to, and underlying, the religious attentions we have already found Mondrian articulating. Meanwhile, the relationships within and between such classic paintings as these also become 'meta-relationships', without compromising the integrity of any one rendition. Looking at one of these paintings is hardly neglecting the other.

[23]

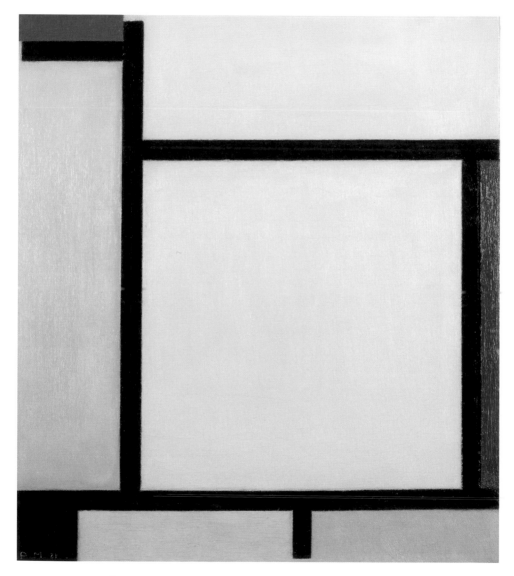

FIG.14 | PIET MONDRIAN
Composition with Red, Blue, Black, Yellow, and Grey, 1921
Oil on canvas, 39.5 × 35 cm
Haags Gemeentemuseum, The Hague

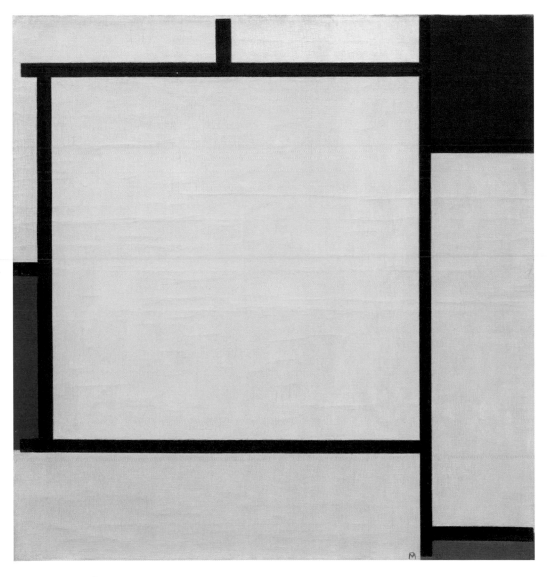

FIG.15 | PIET MONDRIAN
Tableau 2, 1922
Oil on canvas, 55.6 × 53.4 cm
Solomon R. Guggenheim Museum, New York

Well, for a long time, anything taken to be spiritual in Mondrian's art was swept under the carpet of an extended dalliance with Theosophy, which becomes a red herring if the painter was basically a Reformed Christian. Evidently he did set out as a more active and reflective Calvinist or, should we say, Neo-Calvinist than has been supposed.

It is widely known that Mondrian left his pious father's Dutch Reformed Church. But when he moved to Amsterdam in November 1892 he joined a new church, the Gereformeerde Kerken in Nederland (Reformed Churches in the Netherlands), which included parishes attached to the famous preacher and politician Abraham Kuyper (1837–1920). Kuyper was a liberal hero who became prime minister on the strength of his Anti-Revolutionary party, thanks to a policy of segregating Protestants, Catholics and others (which sounds rather like *apartheid* to me). Mondrian's father was a friend of Kuyper, though not a member of his church. On moving to the cultural capital, the twenty-year-old Mondrian began confirmation classes in the new church, and from July 1893 he was listed as confirmed; five months later he started to paint *Thy Word Is the Truth*. Only some twenty years later, on moving to Paris, was Mondrian's church membership 'de-registered' – an administrative procedure not implying withdrawal.[29]

The new church was a hotbed of the tendency called Neo-Calvinism, in which contributions to culture as well as social life might be considered to be close to churchly.[30] Less well known than Kuyper, however, is his protégé Herman Bavinck (1854–1921) – in the next generation of clergy, closer to Mondrian in age. Like Kuyper, he also studied modern culture at Leiden, though on finishing the doctorate he reflected that while these secular studies had benefits, they were also a 'spiritual impoverishment'.[31] Kuyper was the celebrity, while the younger Bavinck was more like the introspective Mondrian.

Some scholars have already brought the popular Kuyper into the orbit of the painter;[32] but, though he pioneered the notion of culture as part of a Christian mission, Kuyper was a more nineteenth-century figure. His response to impressionist painting in 1894 – 'at first sight one sees … bubbles and daubs of paint, and even tints and lines, but not *the image*; and only after repeated attempts a view is finally

obtained' – amounts to visual fundamentalism.[33] Speaking on 'Calvinism and Art' in his 1898 Stone Lectures, in America, Kuyper praises the triumph of ordinary people in Dutch realism; but the closest he comes to anything modern is Rembrandt[34] – about whom there was actually a conservative anti-modern cult at the time.

Herman Bavinck, the theologian of the new church who took the chair of theology at the Free University of Amsterdam after Kuyper, also went to deliver Stone Lectures, in 1908–9. In his lecture on 'Revelation and Culture' art is not a special theme, but Bavinck is decidedly more culturally discerning.[35] Besides, artists are likely to be interested in Bavinck because he champions a sense of divine 'creativity' in the face of the fallen world, with his 'trinitarian idea that grace restores nature'.[36] This allows Christians – and others receiving 'common grace' – to re-make the fallen world, 'creat[ing] no new cosmos but rather mak[ing] the cosmos new'.[37] In turning to this cerebral younger theologian, we discover a brilliance that would have attracted Mondrian.

Admittedly I am drawn to Bavinck by not wishing to take an easy route to the 'public intellectual' Kuyper; but my assumption is also that a Mondrian who dropped out of one Calvinist church only to be confirmed in another was not necessarily a constitutional liberal, and may well have been interested in the most serious Reformed Dutch theology available. In his maturity I can even imagine him in accord with Bavinck's opposition to Theosophy. Kuyper did not like it either; but Bavinck went head-on, saying that Helena Blavatsky and Annie Besant, both key figures in the Theosophy movement, were renegade Christians drawn to Buddhism.[38]

With Mondrian's thinking in mind, let us inquire into the themes of individual justification and the more social dimension leading into the kingdom of God in Bavinck's definitive *Reformed Dogmatics* (1895–1901), published while Mondrian was a student. Here we must obviously be selective, faced with a 3,000-page treatise; yet certain key themes recur in the work like prominent themes in music.

Bavinck brings out the unique asymmetric reciprocity of theological justification:

in the gospel God brought to light a righteousness apart from the law … This righteousness, therefore, is not opposed to his grace, but includes it as it were and paves

[27]

the way for it. It brings out that God, though according to the law he had to con-
demn us, yet in Christ has had different thoughts about us, generally forgives all our
sins without charging us with anything ... Justification, therefore, is not an ethical
but a juridical (forensic) act ...[39]

And: as 'the work of re-creation ... can in its totality also be called a rebirth ... so it
is also from beginning to end a justification, a restoration of the *state* and the *condi-
tion* of the fallen world and humankind in relation to God and to itself'.[40]

For Bavinck, Calvin's sense of justification 'gained a double advantage' over
Luther's, by separating faith and repentance: 'faith could now be much more
closely related to justification, and justification could now be viewed in a purely
juridical sense as an act of acquittal by God ... Reformed theology owed to Calvin
its clear insight into the religious character of justification.' This, then, is where we
see how the Mondrian of 'equivalent plastic relationships' hoped that comprehend-
ing his paintings might actually inspire people towards effecting the kingdom. That
might seem a pipe dream unless one heard something such as this in a sermon:
'Faith and justification ... are not the sum and substance of the order of salvation.
Luther tended to favor stopping there.' But 'since repentance was included in the
Christian life, Calvin could do justice also to its active side ... [F]aith cannot stop
at the forgiveness of sins but reaches out to the perfection that is in Christ, seeks
to confirm itself from works as from its own fruits ...'[41]

At the end of his mammoth *Reformed Dogmatics*, Bavinck links personal justifi-
cation with the kingdom, since after the Second Coming and the Last Judgment a
'Renewal of Creation' occurs. This ought to surpass even secular hopes for an opti-
mistic conclusion, he says.[42] In the end, believers and fellow travellers 'enter into' a
'fellowship' that, 'though in principle it already exists on earth, will nevertheless be
incomparably richer and more glorious when all dividing walls of descent and lan-
guage, of time and space, have been leveled, all sin and error have been banished,
and all the elect have been assembled in the new Jerusalem'.[43] Then: 'The organism
of creation is restored'; and '[t]he great diversity that exists among people ... is ...
made serviceable to fellowship with God and each other'.[44]

What could be more Mondrianesque than the sense of a finally perfectly bal-
anced abstract composition proffering a world of men and women all differently

'justified' and enjoying a happy society, by no means without contradiction, but reciprocally cooperative? To consider this 'utopic' pie in the sky must be wrong because the kingdom or the New Jerusalem is as material as the present world; in fact, it *is* this world. And note: 'All this spells the collapse of spiritualism'.[45] In Bavinck's *Reformed Dogmatics*, fine art brings us *part-way* to the kingdom: true, it 'cannot close the gap between the ideal and reality', but it can give us 'distant glimpses of the realm of glory'.[46] Perhaps Mondrian's Neo-Plasticism goes a step farther, offering less distant glimpses of sheer justification than most representational art manages to do.

Can we pair with this sense of parts actively participating in an 'equilibrated' whole something comprehensively Bavinckian in theology? Perhaps. In 1919–20 ('Natural reality and abstract reality: A trialogue …') Mondrian writes:

> Yes, all things are a part *of the whole: each part obtains its visual value from the whole and the whole from its parts. Everything is expressed through* relationship. *Color can exist only through* other *colors, dimensions through* other *dimensions, positions through* other *positions that oppose them. That is why I regard relationship as* the principal thing.[47]

Now consider the following passage in the *Reformed Dogmatics* as applicable to the implicit social relationality symbolically built into the compositional relationality of Mondrian's painting:

> In short, the counsel of God and the cosmic history that corresponds to it must not be [N.B.] pictured exclusively … as a single straight line *describing relations only of before and after, cause and effect, means and end; instead, it should also be viewed as* a systemic whole *in which things occur side by side in coordinate relations and cooperate in the furthering of what always was, is, and will be the deepest ground of all existence: the glorification of God.*[48]

As thinking of this order was demonstrably at stake in Mondrian's Reformed generation in the Netherlands, it ought to be admitted into our hermeneutics of interpretation.

CONTINUITY AND AFTERLIFE OF THE CLASSIC PHASE

Mondrian was still in Paris during the second decade of his classic phase in the 1930s. The most surprising development – not so momentous for a less rigorous composer

– is his twinning of the black line.[49] Over time, he does move from linear singularity to duality and to plurality; but the first, momentous, move was at or about the moment of *Composition with Yellow and Double Line*, 1932 (fig.16), now in the Scottish National Gallery of Modern Art.

The double-line device might conceivably derive from a British painter known to the artist in Paris, Marlow Moss (1889–1958), who at the time was emulating Mondrian's Neo-Plasticism – itself an act of doubling.[50] Yet the twinned line belongs to a development, within Mondrian's oeuvre, of attention to the line as much as to colour. Thus on the threshold of the classic period we find contiguous irregular colour patches separated by grey lines which, as bands, look scored on either side by finer black lines, as in several *Compositions* of 1920, which might have suggested twinned lines; or the similarly thin darker borders of the graphic lines prominent in *Tableau-Poème textuel*, a 1929 lithographic collaboration with the poet, painter and critic Michel Seuphor (1901–1999). But I want instead to suggest a source in the artist's practice. Mondrian often shows a habit of speedily doubling his lines in sketching out compositions, as workmen often do in sketching on the nearest flat surface: witness a typical notebook page, perhaps from about 1929/31 (fig.17). Scrutinising his own study drawings could thus have provoked the twinning idea.

In any case, the Edinburgh work – bought from the studio by another British painter, Winifred Nicholson (1893–1981) – is excellently concise, not simply 'reductive'. A violin sonata is not necessarily more reductive than a violin concerto. It also stands at the start of a group of several other significant works. Indeed, *Composition with Yellow and Double Line* (fig.16) has only four lines. Two are in a tidy parallel pair, with a white space between which is wide enough to be a band. The two others could not be more different: perpendicular, of different lengths, and one split in two as it skirts the very edge, half atop the surface, half along the stretcher edge – as if it wants to be '($\frac{1}{2} + \frac{1}{2}$)' instead of just '1'. Also, the painting's slim right angle along the bottom edge makes, with so few lines, for a state of affairs in which the top edge is divided by one line into two; the left side, by two into three; the right side, by three into three (as if that were possible!); and then at bottom, we could almost say, is a line gone infinitely long and undivided. And, though related

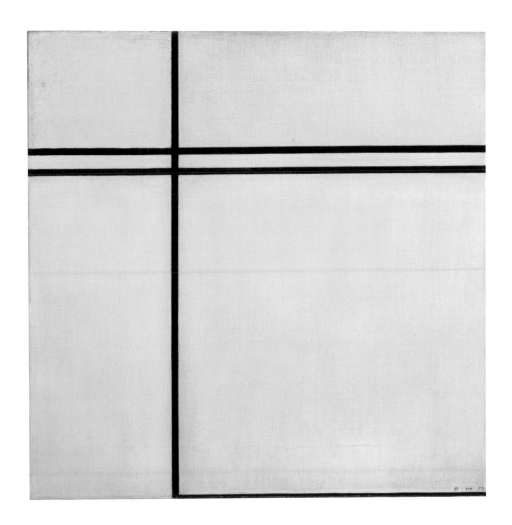

FIG.16 | PIET MONDRIAN
Composition with Yellow and Double Line, 1932
Oil on canvas, 45.3 × 45.3 cm
National Galleries of Scotland, Edinburgh

diagonally, the edge of the line at bottom right, is met by the yellow colour patch at upper left, also bleeding over two edges, side as well as front, as if resembling an enamel compartment in metalwork.

I was speaking to a cousin of mine about this work. She had asked me what was especially interesting about it, which happily provoked me to say that in an artistic situation with so few variables, every one may become important for its potential sign value, so that if Mondrian shows us that he can take one of his lines over the stretcher edge, an alternative opens up about whether to do that or not, and we get to see that an intellectual decision has been made before our eyes. Some reserve is also called for, too, because to go around the corner too regularly might produce a run-on decorative, instead of structurally considered, effect.

Perhaps Mondrian's own reserved complexity, too, concerns how or why there can be no simply linear genealogy to Mondrian's work. It is as if, as soon as we note the passing on of a characteristic, the pattern became more complicated by noticing discrete collateral traits. The Edinburgh painting does have a slightly younger sibling, in a Basel private collection: *Composition with Double Line and Yellow and Blue*, 1933 (fig.18). There the half-line at the bottom becomes slightly wider, with a blue area below. This situation often develops in the classic phase: that the painter had as his basic idea an essentially variable formula, rendering it as if with alternative turns of phrase. The widening of a line, for example, as here, takes on a categorical aspect, as a source of conceptual variability, moving from a line to a stripe or a band. Such distinctions take on great subtlety, as in – five years after the Edinburgh painting – *Composition of Lines and Colour, III; Composition with Blue*, 1937 (fig.19), where no fewer than three line or stripe widths surround the vertical blue rectangle and the similar white rectangle above. And then, say, by a thematic of yellow – for multiple rhizomes (like creeping rootstalks) can often be followed – a painting begun in London and finished in New York: *Painting No.9*, 1939–42 (fig.20), with almost no line variation but with tabs inserted between twin and triplet lines, serves to connect the Edinburgh Mondrian with Mondrian's eventual activity in America.

Soon Mondrian became the doyen of abstract painting in New York, on such a broad-church basis that he was one of the earliest to affirm Jackson Pollock's

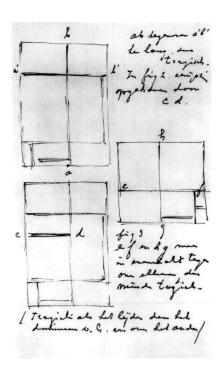

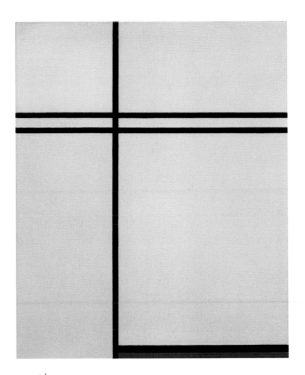

FIG.17 | PIET MONDRIAN
Sketch in a letter to Albert van den Briel, 1929/31
Pencil on paper; dimensions and location unknown

FIG.18 | PIET MONDRIAN
Composition with Double Line and Yellow and Blue, 1933
Oil on canvas, 41 × 33.5 cm
Private collection, Basel

(1912–1956) utterly different approach. Mondrian's extended influence on subsequent abstraction is a study in itself, but we can at least touch on a few contemporary cases where Calvinism of one sort or another has been part of the milieu.

This past spring, I was thinking of the Edinburgh Mondrian while visiting the Robert Rauschenberg (1925–2008) exhibition at the Museum of Modern Art, after its having been at the Tate Modern. With no expectation of finding any formally similar work, I noticed the structure of an early painting, done a few years after Mondrian's death, when this American Southerner of more or less Calvinist fundamentalist (Church of Christ) family was still in his twenties.[51] The work is *Untitled (Asheville Citizen)*, 1952 (fig.21), in oil with a local newspaper from a

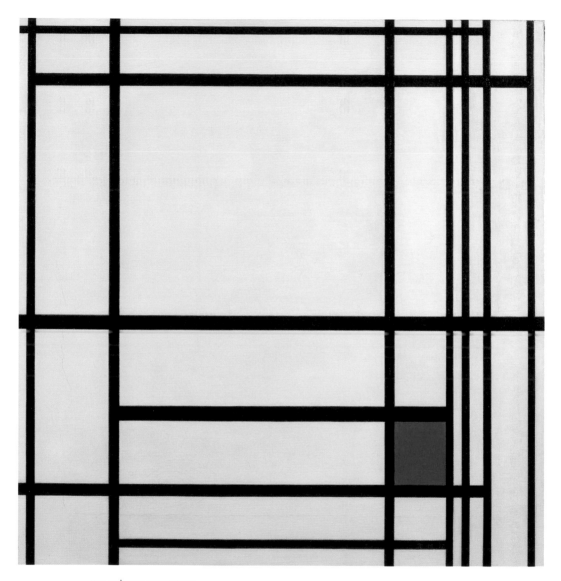

FIG.19 | PIET MONDRIAN

Composition of Lines and Colour, III; Composition with Blue, 1937
Oil on canvas, 80 × 77 cm
Haags Gemeentemuseum, The Hague

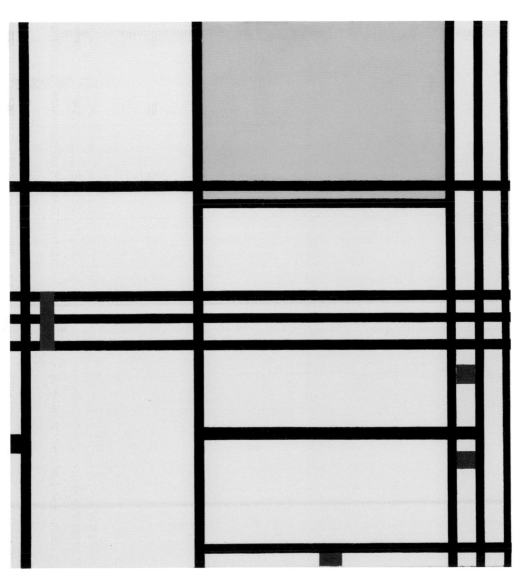

FIG.20 | PIET MONDRIAN
Painting No.9, 1939–42
Oil on canvas, 79.7 × 74.3 cm
The Phillips Collection, Washington DC

FIG.21 | ROBERT RAUSCHENBERG
Untitled (Asheville Citizen), 1952
Oil and newspaper on canvas, two panels, 188 × 72.4 cm
Museum of Modern Art, New York

town close to Black Mountain College, where Rauschenberg studied, glued to two joined canvases. Obviously this has nothing to do with Mondrian stylistically; but structurally speaking, the upper right-hand rectangle of its centred image, defined by the gutter and cuts in the two-page spread, resembles the treatment of the upper left-hand rectangle in the Edinburgh Mondrian and its Basel relative (and other Mondrians as well).

Mondrian was already a presence in town when the Canadian painter Agnes Martin (1912–2004) was finishing her bachelor's degree in New York. Quite aside from Martin's later obsession with the grid, certain lasting elements, such as singular and twinned bars separating colour fields, can be found early on as well as in late work. From as early as the late 1950s there is evidence of Mondrian, as in an often reproduced *Untitled* field painting of 1959 with violet above the centre and grey below, interrupted by a pair of black and white horizontal stripes; and as late as another *Untitled* field painting of horizontal bands, from about 2000 (fig.22), where Martin offers a subtly Mondrianesque sense that the banding of yellow, versus white, is pale enough to evoke a pair of whites.

Martin's basic Calvinism is sometimes referenced only to be glossed over: some do not really want to see the wood for the trees. It is well known that Martin was raised by

FIG.22 | AGNES MARTIN
Untitled, c.2000
Acrylic and traces of graphite on canvas, 152.4 × 152.4 cm
(Agnes Martin Catalogue Raisonné L.L.C. no.1311)
Private collection, Taos, New Mexico

Scottish Presbyterians in Western Canada, but everyone seems to sidestep what that entailed by a consensus that she was 'never religious' and yet was 'the most matter-of-fact mystic', as Peter Schjeldahl puts it.[52] I would have thought that many religious mystics were very matter-of-fact; but the point is that Schjeldahl ends his review of an Agnes Martin retrospective with a quotation from Martin's own 'marvelous' essay 'On the perfection underlying life' (1973), in which her immediate subject is sometimes feeling a 'panic of complete helplessness', and the return therefrom: 'the helplessness when fear and dread have run their course, as all passions do, is the most rewarding state of all'.[53] I submit that Martin's telling phrase 'fear and dread' is clearly a Calvinist cliché. It sounds biblical, but it is not: it occurs only once in the King James Bible (Exodus 15:16) and nowhere in the Revised Standard Version. But, as Google testifies, it does occur in many a scriptural commentary by Calvin as well as in his *Institutes*.

As for Britain: five years ago, the Courtauld Gallery mounted a dual exhibition of Mondrian and Ben Nicholson (1894–1982; husband of Winifred Nicholson) – an interesting parallel. But I find myself completely distracted by the photograph accompanying Frances Spalding's review in *The Guardian*, as illustrating a mere detail from Mondrian's *Composition B (No.11) with Red*, 1935 (Tate).[54] This became amazing evidence that there is something hopelessly inadequate – let's say, *unjustified* – about a fragment of a Mondrian composition. At the same time, however, it reminds me of how the present-day Edinburgh artist Alan Johnston (b.1945), as in an *Untitled* painting of 2013 (fig.23), offers not-dissimilar dispositions yet making them manifestly integral wholes.

Instead of dwelling on Johnston's resort to such utterly natural materials as beeswax, charcoal, even elemental titanium, plus unbleached linen, as if to run from there to David Hume on 'natural theology', I want to acknowledge his long-standing concern with two Scottish thinkers relevant to our larger question, hoping to invoke an iconology of Johnston's milieu in today's Edinburgh. For I think I've never talked with this artist-friend without his bringing up at least one of two modern Scottish thinkers. First: the scientist and social planner Sir Patrick Geddes (1854–1932), a contemporary of Herman Bavinck. He is normally treated as one who had given up on religion, yet Geddes's son affirms that, although study under

FIG.23 | ALAN JOHNSTON
Untitled, 2013
Acrylic titanium white, pencil, charcoal and beeswax on linen, 72 × 60 cm
Marina + Piet Meijer Collection, Therwil, Basel-Landschaft

Thomas Henry Huxley 'shocked his Presbyterian father …, [he] never lost the Scottish traditions of family worship and of faith as a lifelong quest'.[55] Second: George Elder Davie (1912–2007), whose essay on 'Kemp Smith and the metaphysics of original sin', in *The Crisis of the Democratic Intellect* (1986), might be a good place to start a discussion of Neo-Calvinism in regard to Scotland – not something that can be settled here and now.[56]

In any event, a conclusion rises up out of these speculations. It is encouraging that some scholars have lost patience with the 'placebo' Theosophical view of Mondrian, as if one of the great painters of the West had no spiritual mother tongue and had to make do with Esperanto. I have tried to identify the tongue in question. Not that we expect everything about an artist to derive from personal convictions or ideology; but is it possible to draw a broader lesson from tracing this artist's background? In the century since Wassily Kandinsky (1866–1944) published *Concerning the Spiritual in Art* (1911), the 'spiritual' has become a vapid predicate as applied to non-objective art: a mere licence of approbation, requiring no critique. Likewise with appeals to the 'transcendental', though this term may actually hold promise if we look again to Kant. Even those at odds with Kant's aesthetics may gain something from *The Critique of Pure Reason* (1781), where the transcendental is by no means something floating above us inaccessibly in the ether but, quite instead, that which *underlies* our every presupposition. That is what we have sought in scrutinising a certain key feature of Mondrian's mature thinking. If this means that some abstract painting, including Mondrian's, entails metaphysical ideas – even if some, sometimes for good reason, does not – so be it.

NOTES & REFERENCES

1. Theosophy is only the most serious distortion of this painter's proclivities. For more textual evidence, along with popular notions of Mondrian's vertical and horizontal intersections being symbolic of sex and of his compositions supposedly proffering direct Cross motifs, see Masheck 2015. That text also deals with Theosophy, where the much-cited evidence that Mondrian always held onto a printed 1908 lecture by Rudolf Steiner is dubious because Steiner was then abandoning Theosophy to found 'Anthroposophy' – named to show no pretence of divinity. Charles Pickstone suggests that about 1900 Theosophy 'neatly filled the gap left by the failure of orthodox Christianity to appear intellectually respectable, promising admittance into occult secrets and an escape from the scientific materialism which was associated with what was seen as the vulgarity of commercial bourgeois culture'; it purported to address 'the dilemma of educated and scientific people who, alienated from Christianity and unversed in theology, could so easily fall into the maw of gnosticism dressed up in scientific clothes' (Pickstone 1986, p.189).

2. Henkels 1987, pp.151–52; Welsh & Joosten 1998, vol.1, p.151, cat.A11.

3. The similarity between such heraldic shields in church interiors by Pieter Saenredam and de Witte and the lozenge paintings of Mondrian is also noted by Meyer Schapiro (Schapiro 1978, p.259, n.7).

4. Once volume could be newly evoked by cubist means, a post-impressionist head set before a flat background risked backsliding (cf. Masheck 2010, chapters iii, iv).

5. Immanuel Kant, *The Critique of Practical Reason*, Thomas Kingsmill Abbott (trans.), online publication of the University of Adelaide (2014): https://ebooks.adelaide.edu.au/k/kant/ immanuel/k16pra/index.html (accessed 15 August 2017), beginning of 'Conclusion'. Videotape of interview: Rose 1996.

6. Bois 1994, p.338. One hardly trusts a supposed Kantian writing a book with the misguided title of Bolland's *Pure Reason: A Book for the Friends of Wisdom* (1904). Bois says that, despite his readings, Mondrian 'never completely discards Schoenmaekers' use of the concept of "determination", which is rigorously antithetical to that of Hegel' (Bois 1994, p.369, n.97); but what about Calvinist predestination? He also develops an interesting Hegelian heuristic of Mondrian's development, with the painter – perhaps informed about Hegel through Bolland (who may have used the term 'equilibrated relationship') – following a grand algorithm of progression, in the sense of formal development, followed by retrenchment, in the sense of what could next be done without. Bois, too, plays down Theosophy and M.H.J. Schoenmaekers. See also Cooper 1998, pp.118–42.

7. I have noted Luther's use of the verb *aufheben* in another great passage of the Epistle to the Romans: '[I]s God the God of Jews only? Is he not the God of Gentiles also? Yes, of Gentiles also, since God is one; and he will justify the circumcised on the ground of their faith and the uncircumcised through their faith. Do we then overthrow the law by this faith (*heben wir denn das Gesetz auf*)? By no means! On the contrary, we uphold the law (Rom. 3:29–31; RSV)'; excerpt from my keynote address 'Convictions of things not seen: A change from Suprematism to Constructivism in Russian revolutionary art', for the Art and Christianity Enquiry conference on 'Art and Christianity in Revolutionary Times', Boston, July 2012: Masheck 2012, p.5.

8. Retrieving the now-abused term 'classic', I can

think of the Erechtheum, on the Acropolis, as evocative of Mondrian thanks to its astute asymmetries, in ground plan as well as elevation. Nicolas Calas, the Greek Surrealist poet and New York art critic (writing for me as editor of *Artforum*, January 1978), wrote: 'When Mondrian substitutes equivalence for symmetry, the replacement is a model of perfection unknown before him'; see Calas 1985, p.241.

9. Calvin 1936, vol.1, p.818.

10. Newman 2012, pp.70, 109.

11. Mondrian 1986, p.256.

12. Ibid., p.50.

13. Ibid., p.51.

14. Ibid., p.62.

15. Ibid., p.66.

16. Matthes 1994–95, p.71.

17. Mondrian 1986, p.78. Later, in 'The new art – the new life: The culture of pure relationships' (1931), concerning people's readiness to take on the utopian morality of the world to come: 'Today's mentality is not capable of realizing [it], but it is capable of *observing the logic of justice*' (Mondrian 1986, p.273).

18. Mondrian 1986, p.99.

19. Ibid., p.118.

20. Ibid., p.119.

21. Given the general notion of the 'plastic arts' as visual arts where form endures in virtue of the physical properties of materials, the theosophist Helena Blavatsky had written rather implausibly that 'the origin of everything is the "plasticist" essence (*de plastische essentie*) that fills the universe' (quoted in Dutch in Bax 2001). But we are not after mystical natural history but a *new* – if anything, non-natural – artistic plasticity. Mondrian's friend Theo van Doesburg,

whose 1917 journal *De Stijl* advanced the single-minded name of the Dutch movement as one aspect of a comprehensive modern style – 'The Style' – knew Schoenmaekers, whose *The New Worldview* (*Het nieuwe wereldbeeld*), of 1915, was followed by *Principles of Visual* [sometimes rendered as 'Plastic'] *Mathematics* (*Beginselen der beeldende wiskunde*), in 1916. Thanks to Joop Koopman for discussing these translations. In Mondrian's 1920 *Neo-Plasticism* book, 'plastics' even extends to concepts: 'Since truth and beauty are basically one, it is not logical to deny the obvious kinship of these two plastics' (Mondrian 1986, p.143); and the essentially dialectical nature of any 'New Plastic' will require an '*equilibrium through opposition of contraries*' (Mondrian 1986, p.146).

22. Mondrian 1986, pp.136–37, 134 respectively.

23. Ibid., p.151.

24. Ibid., p.153.

25. Ibid., p.169.

26. Ibid., pp.205–12, especially p.212.

27. Ibid., p.224. In 'The new art – the new life' (1931), Mondrian had the notion that international peace could be established by mutual armed (needless to say, pre-nuclear) deterrence. Although the Dutch had been neutral in the First World War, they were subjected to severe food shortages during the Allied blockade of North Sea ports.

28. Mondrian 1986, p.291.

29. De Jong 1989. Thanks to Dirk Jongkind for translating.

30. This might be the most theologically problematic feature in the Reformed frame of reference to which Mondrian was called, perhaps notably among any Scottish Calvinists inclined to demur when the World Communion of

Reformed Churches signed the Catholic-Lutheran 'Joint Declaration on the Doctrine of Justification' in 2017, the 500th anniversary year of the Reformation. Certainly anyone considering emphasis on good works as 'Arminian' would after all have been pointing to Arminius as a classically Dutch divine.

31. Bavinck 2003–8, vol.1, p.13 ('Introduction').

32. Studies of Mondrian in the context of Kuyper: Birtwistle 2012; Bratt 2013A (Bratt too has doubts about making Kuyper's the only game in town: see the revisiting of his essay in Bratt 2013B); Jonathan A. Anderson and William A. Dyrness, section on 'Piet Mondrian: Figuring the immutable', in Anderson & Dyrness 2016, pp.174–85.

33. Kuyper 1898A, p.479. There would also have been a problem of stylistic terminology in that, before Post-impressionism was accessible, let alone named as such, the default category was the essentially literary *Symbolisme*, which for Kuyper connoted decadent aestheticism and even Anglo-Catholic churchmanship. In America, he even lectured on 'The Antithesis Between Symbolism and Revelation': see Kuyper 1898B.

34. Kuyper 1932.

35. Bavinck 1909.

36. Bavinck 2003–8, vol.1, p.18.

37. Ibid., p.19.

38. Ibid., p.200. The Dutch painter and Benedictine monk Jan (Dom Willibrord) Verkade (1868–1946), raised an unchurched Protestant, had his curiosity stirred early on by Édouard Shuré's *Les Grands Initiés* (1889). Eventually he wrote in *Yesterdays of an Artist-Monk* (1930): 'Theosophy … does not reckon with the soul's need of grace, and it lacks the Sacraments of the Church. It is a halfway station for the better class of pagans, … a fencing-school for religious dilettantism. If its devotees would employ only one half of the time and effort which they use to initiate themselves into the doctrines of Brahma and Buddha in gaining a deeper understanding of the Christian mysteries, what a splendid increase both in quantity and quality the Church would soon be able to rejoice over. For there is no doubt that among the theosophists there are some rare spirits' (Verkade 1930, p.32).

39. Bavinck 2003–8, vol.4, p.206.

40. Ibid., p.208.

41. Bavinck 2003–8, vol.3, pp.527–28.

42. Bavinck 2003–8, vol.4, p.646.

43. Ibid., p.723.

44. Ibid., p.727.

45. Ibid., p.718.

46. Bavinck 2003–8, vol.1, p.267.

47. Mondrian 1986, p.86.

48. Bavinck 2003–8, vol.2, p.392; emphasis added. Again: '[T]he image of God can only be displayed in all its dimensions and characteristic features in a humanity whose members exist both successively one after the other and contemporaneously side by side' (Bavinck 2003–8, vol.2, p.577). Note: were Mondrian's classic compositions based on a grid, as some presume, we might speak of a simple 'commutative' *equality* of their constituent units. However, having nothing to do with the commutative interchangeability of units in a grid (except for a few experiments in 1918–19), his ensembles evoke instead a 'distributive' proportionality. I borrow the terms of Thomas Aquinas's *Commentary on the Nichomachean Ethics* (Aquinas 1964), on the suggestion of Peter McNamara. This side of Mondrian, whereby the qualitative aspect of proportion, over and against what could have been the armature of a mechanical grid, makes such compositions *more than* constructivist,

analogously to the way Malevich's Suprematism manages to be anything but 'geometric art'.

49. Some take this superficially as decorative, perhaps in the manner of Art Deco automobile grilles. Bois says that the critic Tériade was wrong to raise a charge of decorativeness against classic Mondrians in an article of January 1931; I have sometimes thought that such a charge was only premature, regarding, as Bois says, 'everything that was woven around "the double line" from 1932 onward' (Bois 1990, pp.161, 303 n.13).

50. Welsh 1977, p.26.

51. Anderson & Dyrness 2016, p.298.

52. Schjeldahl, 'Agnes Martin, a matter-of-fact mystic', *The New Yorker*, 17 October 2016, online at https://www.newyorker.com/magazine/2016/10/17/agnes-martin-a-matter-of-fact-mystic (accessed 25 September 2017).

53. Ibid.

54. Frances Spalding, 'Mondrian and Nicholson: An aesthetic journey along parallel lines' (review), *The Guardian*, 3 February 2012, online at https://www.theguardian.com/artand design/2012/feb/03/mondrian-nicholson-parallel-lines (accessed 17 January 2018).

55. Geddes 1949. For Thomas H. Huxley on Hume, religion and evolution, see Huxley 1897, especially chapter viii, 'Theism: Evolution of theology'. Stewart Alan Robertson accounts for Geddes's closeness to his mentor by explaining that Huxley did not produce an evolutionary 'gladiator's show' of Darwinian selection; indeed, when Geddes was professor of botany at Dundee, he 'rallied young minds to faith in the rationality of the universe, in the possibility of progress, in the value of life, in the triumph of justice and truth, if men would but search widely, think deeply, and, above all, labour together for the common gain' (Robertson 1933, p.2). The American Philip Boardman, who studied at Geddes's knee, reports that Geddes tended to accept 'Christian myths … along with all others' (Boardman 1978, p.163); yet he also offers the almost Francis-Thompson-like Geddes poem *The Mystic Catholic*, including the couplet, 'Christ rose not from the dead, Christ is still in his grave, / If thou for whom he died art still of sin the slave' (ibid., p.454). Geddes's early book-length review of a contemporary art exhibition in Glasgow (Geddes 1888) engrossingly deals with the perversion of religious idealism into secular power and moneymaking – well before Max Weber's *The Protestant Ethic and the Spirit of Capitalism* (1905).

56. Davie 1986, especially pp.50, 52.

BIBLIOGRAPHY

ANDERSON & DYRNESS 2016
Jonathan A. Anderson and William A. Dyrness,
*Modern Art and the Life of a Culture: The Religious
Impulses of Modernism*, Downers Grove, Illinois,
2016

AQUINAS 1964
Thomas Aquinas, *Commentary on the Nichomachean
Ethics*, C.I. Litzinger (trans.), Chicago, 1964, 2 vols,
online at
http://dhspriory.org/thomas/Ethics.htm (accessed
21 June 2015)

BAVINCK 1909
Herman Bavinck, 'Revelation and culture', in *The
Philosophy of Revelation: The Stone Lectures for 1908–
1909*, London, 1909, pp.242–69

BAVINCK 2003–8
Herman Bavinck, *Reformed Dogmatics*, John Bolt
(ed.), John Vriend (trans.), 4 vols, Grand Rapids,
Michigan, 2003–8 (1st edn 1895–1901)

BAX 2001
Marty Bax, *Mondriaan compleet*, Blaricum,
The Netherlands, 2001

BIRTWISTLE 2012
Graham Birtwistle, 'Evolving a "better" world: Piet
Mondrian's *Flowering Apple Tree*', in James Romaine
(ed.), *Art and Spiritual Perception: Essays in Honor of
E. John Walford*, Wheaton, Illinois, 2012, pp.225–37

BLOTKAMP 1994
Carel Blotkamp, *Mondrian: The Art of Destruction*,
London, 1994

BOARDMAN 1978
Philip Boardman, *The Worlds of Patrick Geddes:
Biologist, Town Planner, Re-educator, Peace-Warrior*,
London, 1978

BOIS 1990
Yve-Alain Bois, 'Piet Mondrian: New York City'
(1985; 1988), in *Painting as Model*, Cambridge,
Massachusetts, 1990, pp.157–83

BOIS 1994
Yve-Alain Bois, 'The iconoclast', in Rudenstine
1994, pp.313–72

BRATT 2013A
James A. Bratt, 'From Neo-Calvinism to *Broadway
Boogie-Woogie*: Abraham Kuyper as the jilted step-
father of Piet Mondrian', *Kuyper Center Review*
(Grand Rapids), no.3 (2013), pp.117–29

BRATT 2013B
James A. Bratt, *Abraham Kuyper: Modern Calvinist,
Christian Democrat*, Grand Rapids, Michigan, 2013

CALAS 1985
Nicolas Calas, 'Bodyworks and porpoises', in
*Transfigurations: Art Critical Essays on the Modern
Period*, Ann Arbor, Michigan, 1985, pp.235–42

CALVIN 1936
John Calvin, *Institutes of the Christian Religion*,
John Allen (trans.), 7th American edn, 2 vols,
Philadelphia, 1936

CHEETHAM 1991
Mark Cheetham, *The Rhetoric of Purity:
Essentialist Theory and the Advent of Abstract
Painting*, Cambridge, 1991

COOPER 1998
Harry Cooper, 'Mondrian, Hegel, Boogie',
October, no.84 (Spring 1998), pp.118–42

DAVIE 1986
George Elder Davie, 'Kemp Smith and the
metaphysics of original sin', ch.5 in *The Crisis
of the Democratic Intellect: The Problem of
Generalism and Specialisation in Twentieth-
Century Scotland*, Edinburgh, 1986, pp.46–61

GEDDES 1888
Patrick Geddes, *Every Man His Own Art Critic
(Glasgow Exhibition, 1888): An Introduction to
the Study of Pictures*, Edinburgh, 1888

GEDDES 1949
Arthur Geddes, 'Sir Patrick Geddes', *The
Dictionary of National Biography*, 5th
Supplement (1931–40), Oxford, 1949, pp.311–13

HENKELS 1987
Herbert Henkels, 'Mondrian in Winterswijk',
in *Mondrian from Figuration to Abstraction*,
Tokyo, 1987, pp.145–64

HUXLEY 1897
Thomas H. Huxley, *Hume; with Helps to the
Study of Berkeley: Essays*, New York, 1897

DE JONG 1989
J.M. de Jong, 'Piet Mondriaan en de gerefor-
meerde kerk van Amsterdam', *Jong Holland:
driemaandelijks tijdschrift voor beeldende kunst*

en vormgeving in Nederland na 1850, vol.5, no.3
(1989), pp.20–23

KUYPER 1898A
Abraham Kuyper, *Encyclopedia of Sacred Theology:
Its Principles*, J. Hendrik de Vries (trans.), New York,
1898 (1st edn 1894)

KUYPER 1898B
Abraham Kuyper, *The Antithesis Between Symbolism
and Revelation: Lecture Delivered Before the Historical
Presbyterian Society of Philadelphia, Pa.*, Amsterdam,
1898

KUYPER 1932
Abraham Kuyper, 'Calvinism and art', in *Calvinism:
Being the Six Stone Lectures Given at Princeton
Theological Seminary, USA*, London, 1932, pp.216–57
(1st edn 1898)

MASHECK 2010
Joseph Masheck, *The Carpet Paradigm: Integral
Flatness from Decorative to Fine Art*, New York, 2010

MASHECK 2012
Joseph Masheck, 'El Lissitzky: On the side of faith',
Art and Christianity (London), no.71 (Autumn
2012), pp.2–6

MASHECK 2015
Joseph Masheck, 'A Christian Mondrian', in
The Bavinck Review 6 (2015), pp.37–42, online
at https://bavinckinstitute.org/wp-content/
uploads/2016/01/TBR6.pdf (accessed 3 September
2017)

MATTHES 1994–95
Hendrik Matthes, 'Mondrian's "exact plastic of mere
relationship"', *Kunst & Museumjournaal* 6 (1994–
95), pp.71–83

MONDRIAN 1986
Piet Mondrian, *The New Art – The New Life: The
Collected Writings*, Harry Holtzman and Martin S.
James (ed. and trans.), Boston, Massachusetts, 1986

NEWMAN 2012
John Henry Newman, *Lectures on Justification*, reprint, Cambridge, 2012 (1st edn 1838)

PICKSTONE 1986
Charles Pickstone, 'Mondrian, Don Cupitt, and the Cheshire Cat', *Theology*, vol.89, no.729 (May 1986), pp.187–94

ROBERTSON 1933
Stewart Alan Robertson, 'Patrick Geddes', in *A Moray Loon*, London and Edinburgh, 1933, pp.1–11

ROSE 1996
Charlie Rose, 'Mondrian exhibit', on *Charlie Rose* (US television interview programme), New York (Public Broadcasting Service), 4 January 1996, online at https://charlierose.com/videos/8944 (accessed 4 September 2017)

RUDENSTINE 1994
Angelica Zander Rudenstine *et al.* (eds), *Piet Mondrian 1872–1944*, Washington DC, New York and Milan, 1994

SCHAPIRO 1978
Meyer Schapiro, 'Mondrian: Order and randomness in abstract painting', in *Modern Art: 19th and 20th Centuries, Selected Papers, 2*, New York, 1978, pp.233–61

TAYLOR 1992
Mark C. Taylor, *Disfiguring: Art, Architecture, Religion*, Religion and Postmodernism Series, Chicago, 1992

VERKADE 1930
Willibrord Verkade, *Yesterdays of an Artist-Monk*, John L. Stoddard (trans.), New York, 1930

WELSH 1977
Robert Welsh, 'The place of *Composition 12 with Small Blue Square* in the art of Piet Mondrian', in *Bulletin of the National Gallery of Canada* 29 (1977), pp.3–32

WELSH & JOOSTEN 1998
Robert P. Welsh and Joop M. Joosten, *Piet Mondrian: Catalogue Raisonné*, 2 vols (1: *Catalogue Raisonné of the Naturalistic Works (Until Early 1911)*; 2: *Catalogue Raisonné of the Work of 1911–1944*), New York, 1998

ACKNOWLEDGEMENTS

Allow me first to express my gratitude to Edinburgh College of Art for my appointment as Centenary Fellow, in the late 1990s and the 2000s, which enabled a book on Mondrian's contemporary the architect Adolf Loos as well as a published study on the architectural history of the College. Now, however, I am grateful to Prof. Richard Thomson, Watson Gordon Professor of Fine Art in the University of Edinburgh, to Mr Robert Robertson, and to the National Galleries of Scotland, for the honour of delivering this lecture. For particular advice, I thank Ms Gillian Achurch (National Galleries of Scotland), Prof. John Bolt (Calvin Theological Seminary), Prof. Terry Godlove (Hofstra), Prof. David Jasper (Glasgow), Dr Dirk Jongkind (St Edmund's College, Cambridge), Mr Joop Koopman, Prof. Murdo Macdonald (Dundee), Dean Fr Alban McCoy (St Edmund's), Mr Peter McNamara, Dr Peter J. O'Donnell (St Edmund's), Ms Donna Reihing, Ms Charlotte Rodziewicz and Ms Marjorie Welish.

PHOTOGRAPHY AND COPYRIGHT CREDITS

Figs 1, 5, 6, 7, 12 & 14 courtesy Gemeentemuseum Den Haag; fig.3 Residenzgalerie Salzburg, Inv. Nr. 557; photo: Fotostudio Ulrich Ghezzi, Oberalm; fig.4 private collection / Bridgeman Images; fig.8 Mrs Simon Guggenheim Fund. Acc. no.: 34.1942. © 2018. Digital image, The Museum of Modern Art, New York/Scala, Florence; figs 9, 10 & 11 © Stichting Kröller-Müller Museum, Postbus/ P.O. Box 1, 6730 AA Otterlo, The Netherlands; fig.13 © DACS 2018; Gift of Philip Johnson. 496.1970; photo © 2018. Digital image, The Museum of Modern Art, New York/Scala, Florence; fig.15 Solomon R. Guggenheim Museum, New York 51.1309; fig.16 © National Galleries of Scotland, photography by A. Reeve; fig.17 photographed from Angelica Zander Rudenstine et al. (eds), *Piet Mondrian 1872–1944*, Washington DC, New York and Milan, 1994, p.354, original believed lost; fig.18 photo: akg-images; fig.19 courtesy Gemeentemuseum Den Haag, acquired with the support of the Vereniging Rembrandt; fig.20 The Phillips Collection, Washington DC. Gift from the estate of Katherine S. Dreier, 1953; fig.21 © Robert Rauschenberg Foundation/DACS, London/ VAGA, NY 2018; Purchase. Acc. no.: 123.1999. photo © 2018. Digital image, The Museum of Modern Art, New York/Scala, Florence; fig.22 © Agnes Martin / DACS 2018; courtesy Peter Freeman, Inc. New York; fig.23 © Alan Johnston, courtesy Bartha Contemporary, London.